¡Arriba Los Colores!

Coloring Flowers

Adult Coloring Book

By

Sabat Beatto

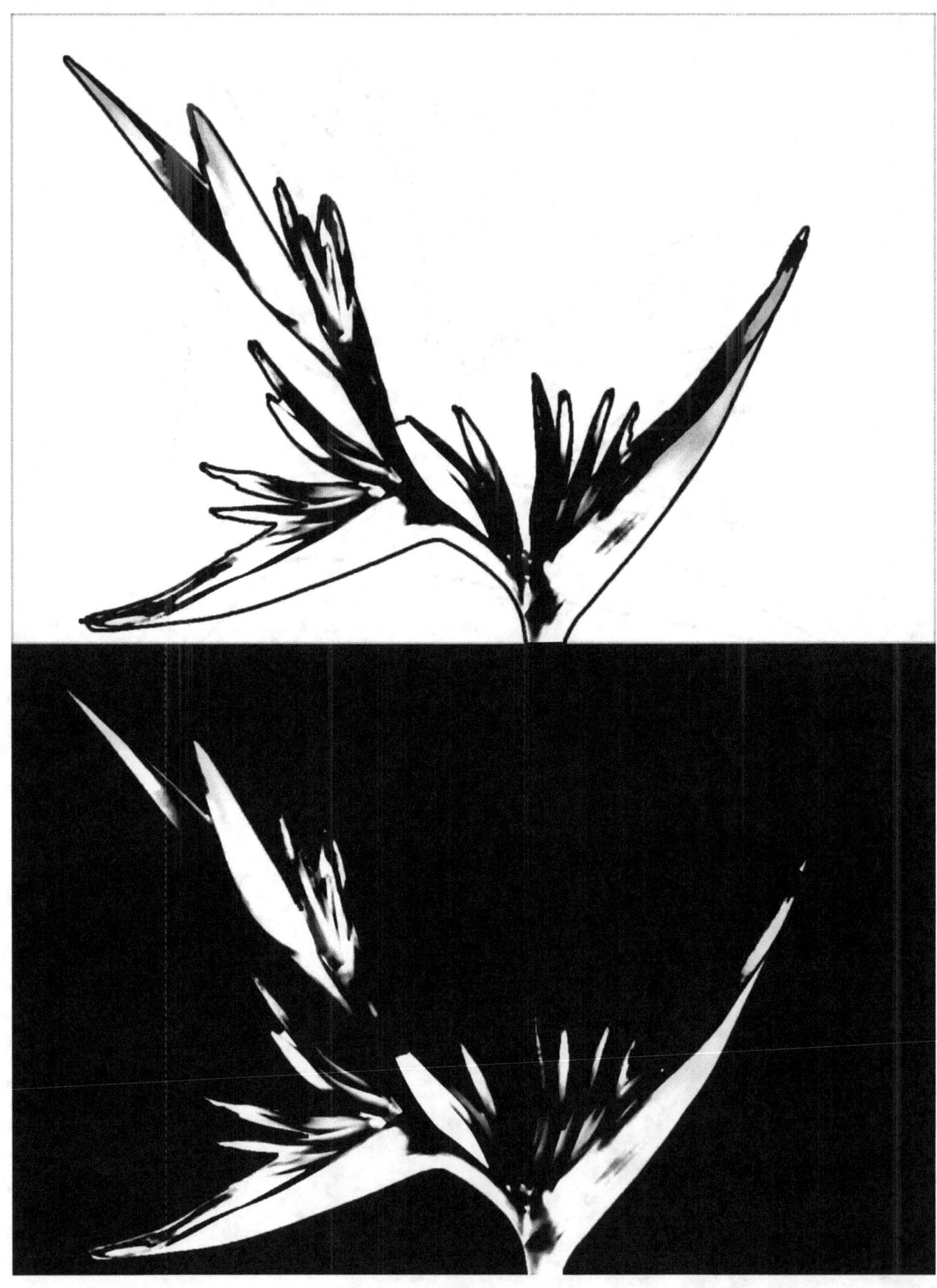

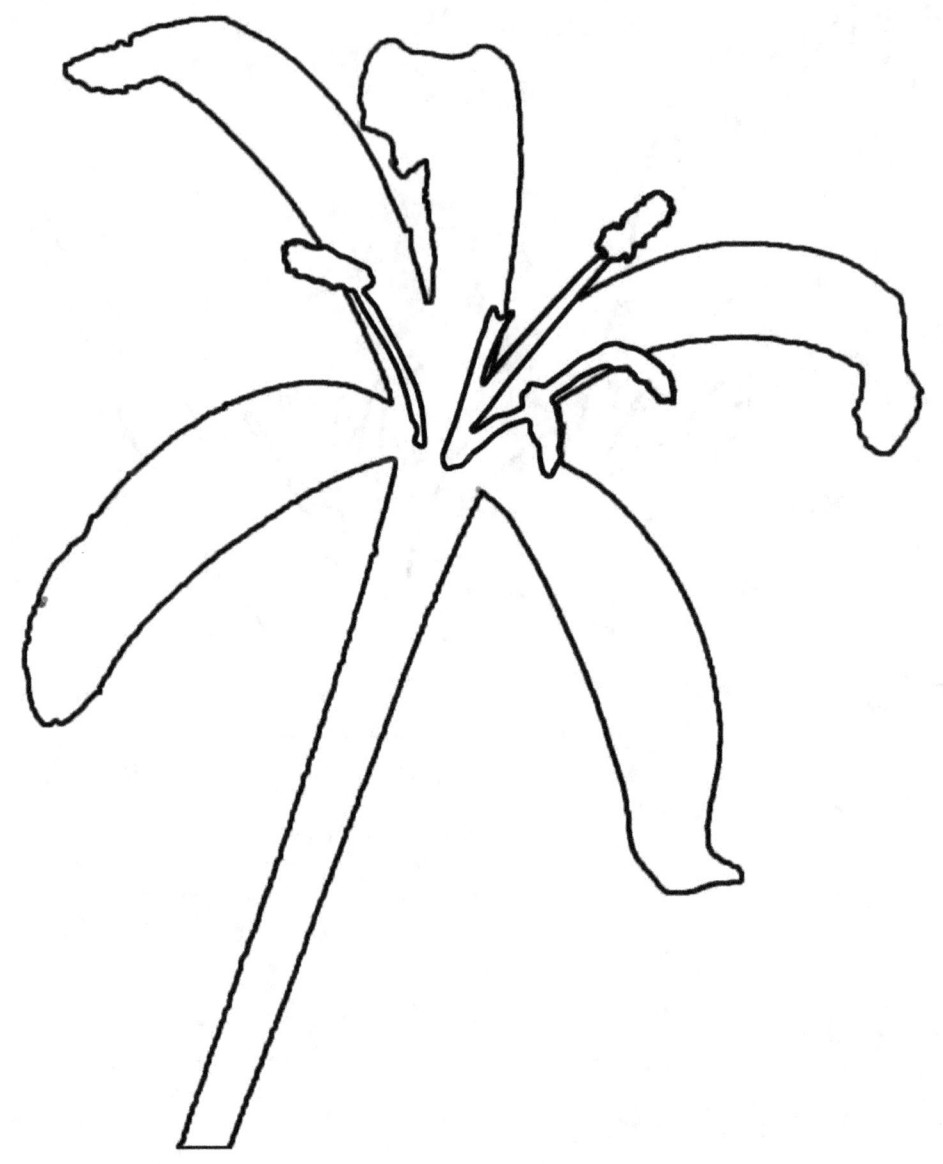

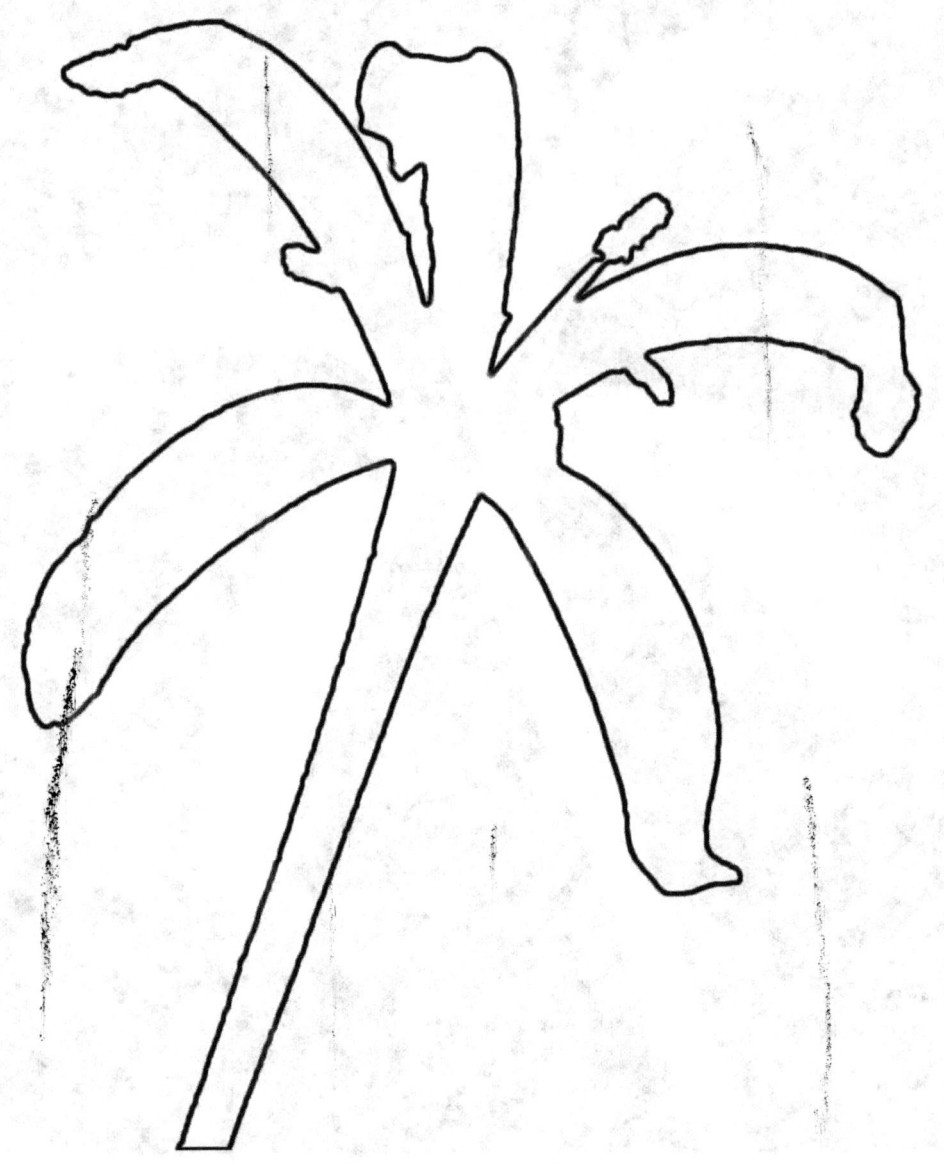

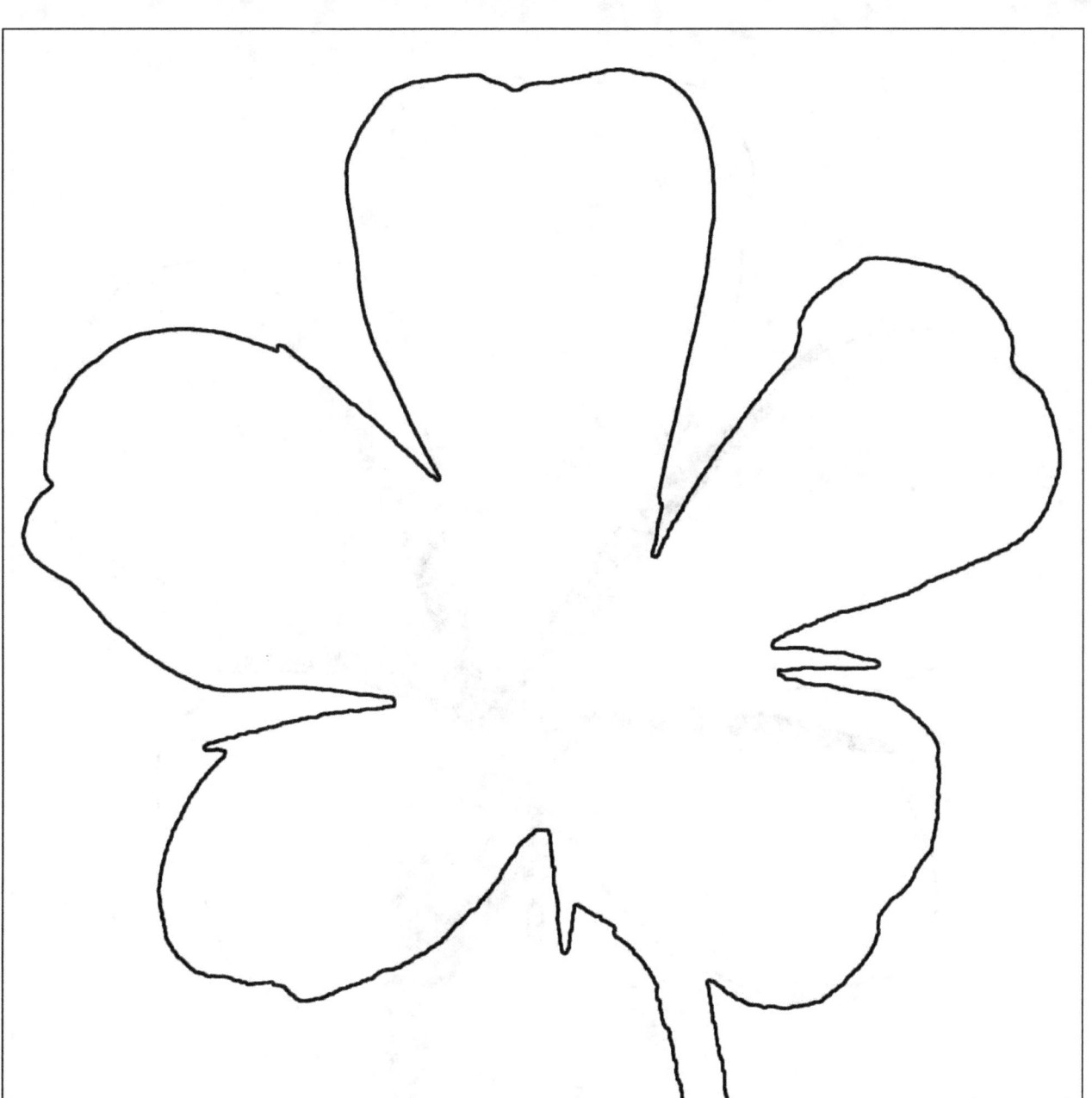

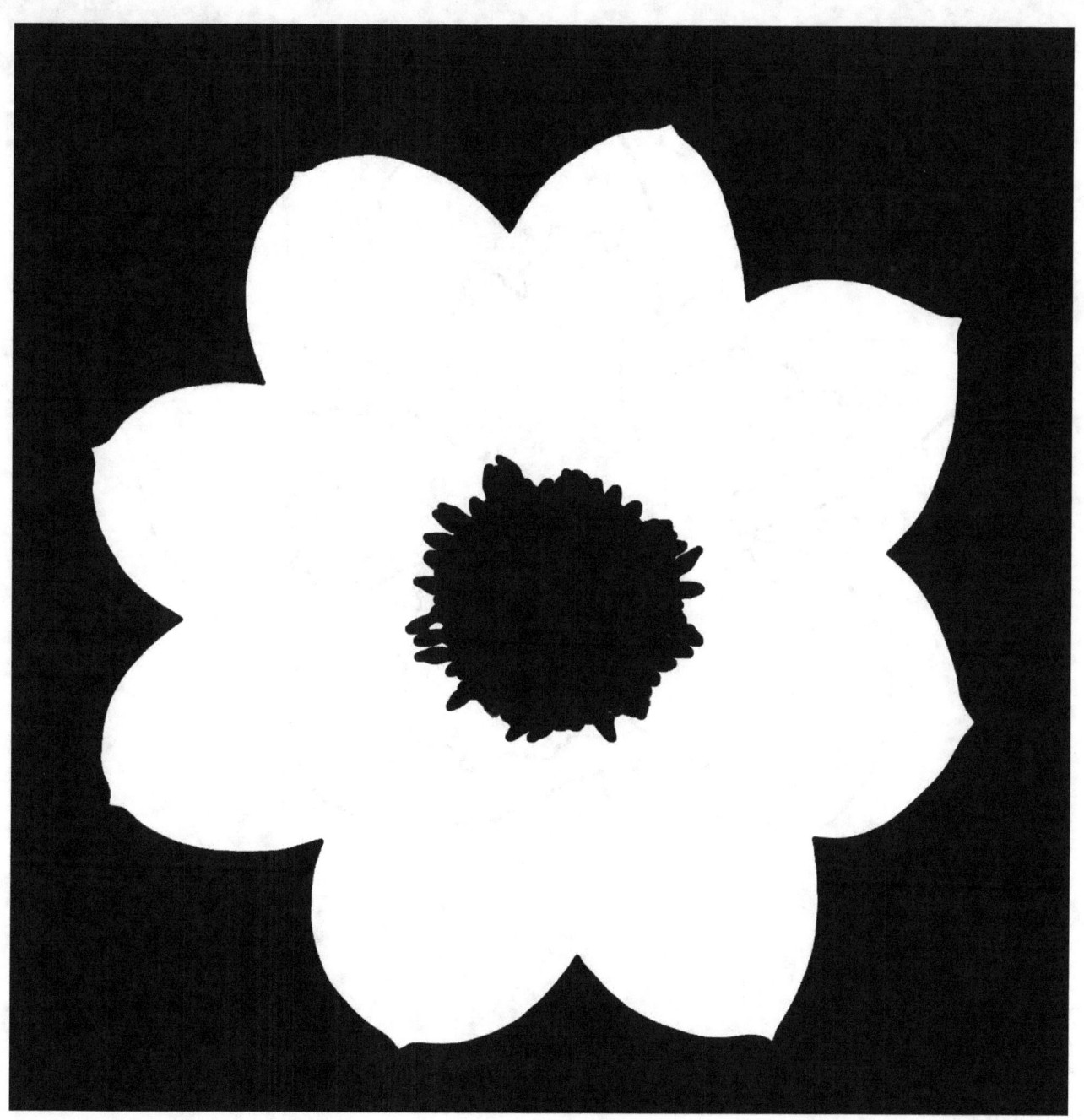

www.ingramcontent.com/pod-product-compliance
Lightning Source LLC
Chambersburg PA
CBHW081151180526
45170CB00006B/2023